SOMETHIN'

PUMPKIN

illustrated by
Jimmy Pickering

written by
Scott Allen

smallfell☺w press

To Harold, Maude and Lady Fish

-JP

To Mom & Dad for giving me
that extra somethin'

-SA

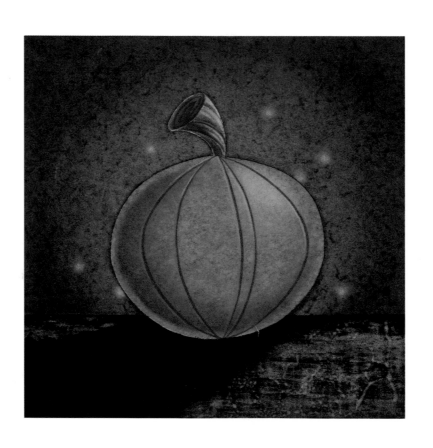

All through October
all 31 days ~
pumpkins play a part
in all sorts of ways.

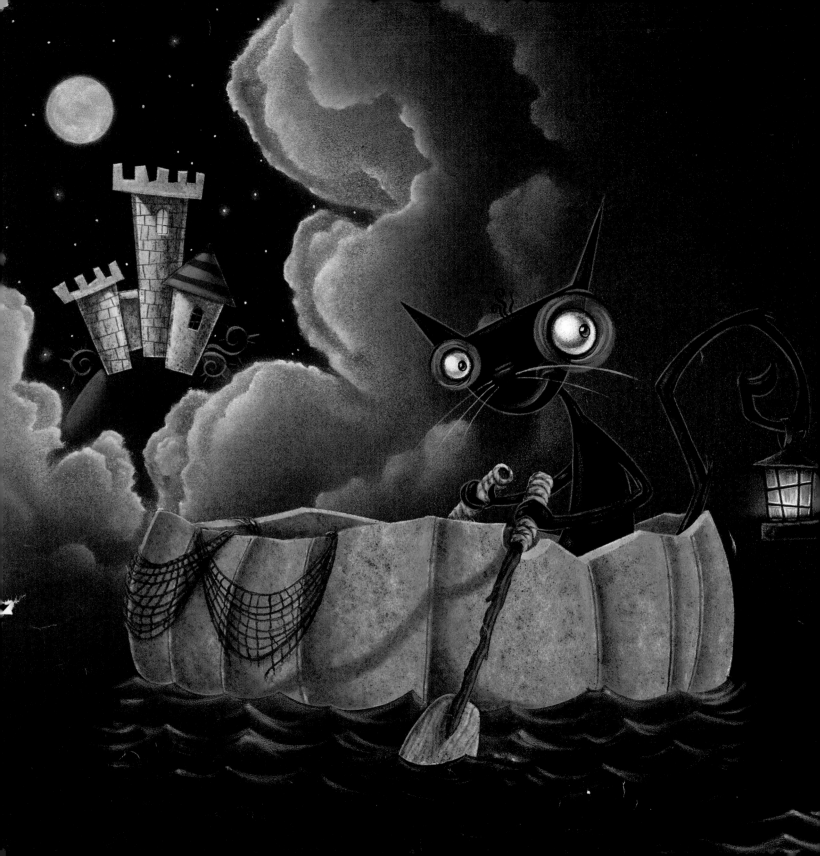

To keep bravely afloat
while crossing a moat

black cats will usually
fashion **a boat**

from half of a pumpkin,
two sticks and a net.

They'll do anything
to avoid getting wet.

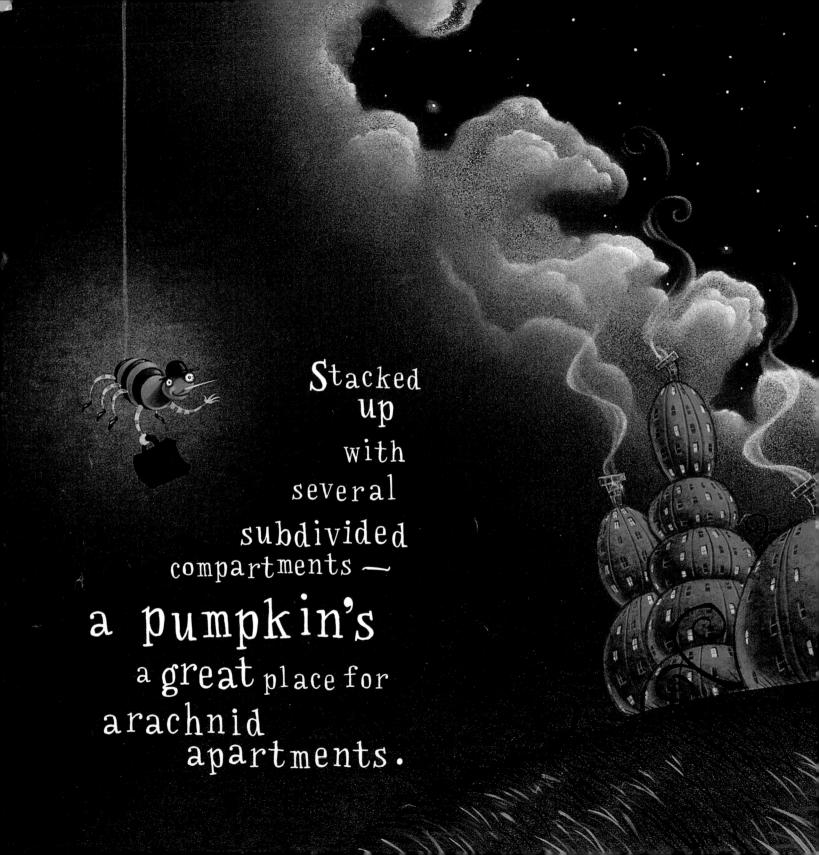

Stacked
up
with
several
subdivided
compartments —

a pumpkin's
a great place for
arachnid
apartments.

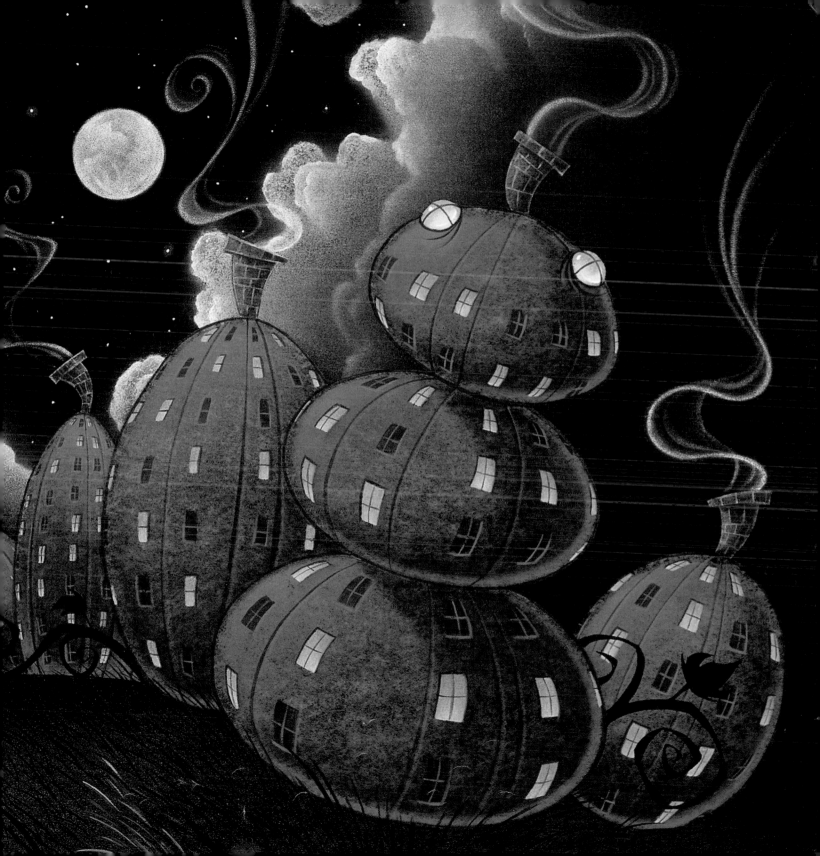

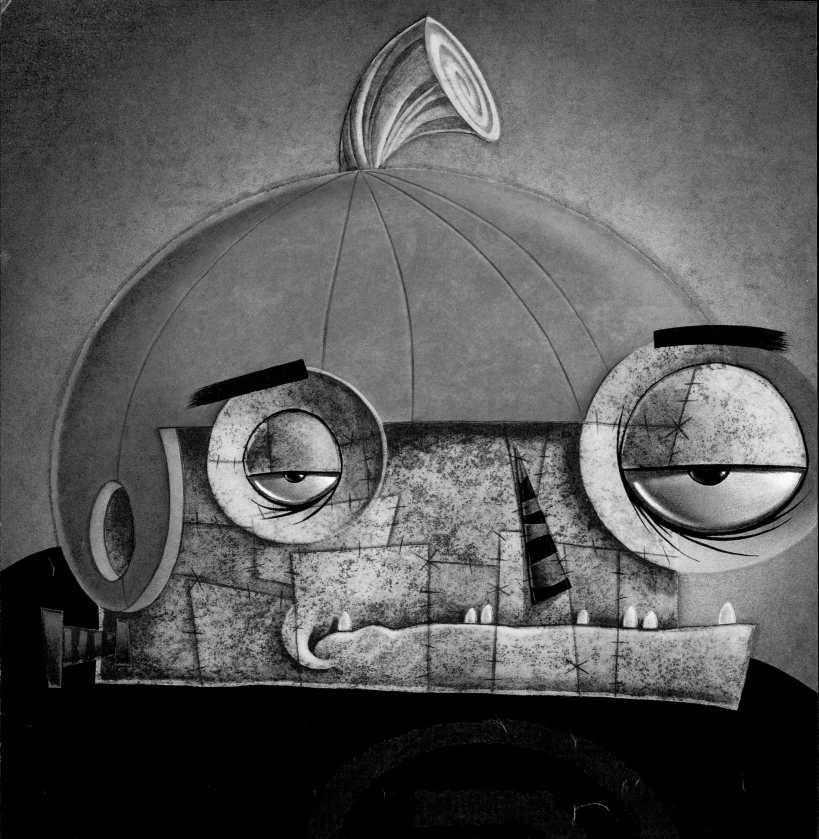

In Frankenstein
FOOTBALL
in all away-games~
they use
pumpkin shells
to bolt-in their
BRAINS.

A robot
with a number
instead of a name -
uses pumpkins to fuel
a computerized brain.

Clamping down on the stems,
then consuming them whole -
there is little restraint
and no self-control.

Chomping more than 100
could mean overload -
causing systems to
crash
and the head to
explode.

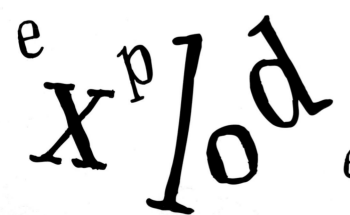

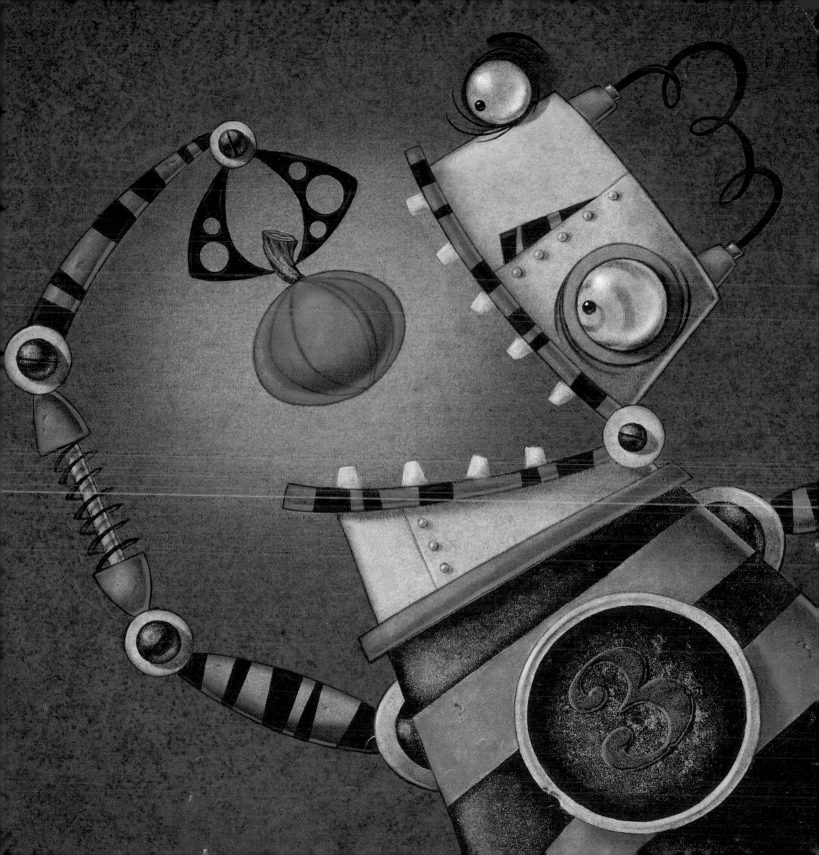

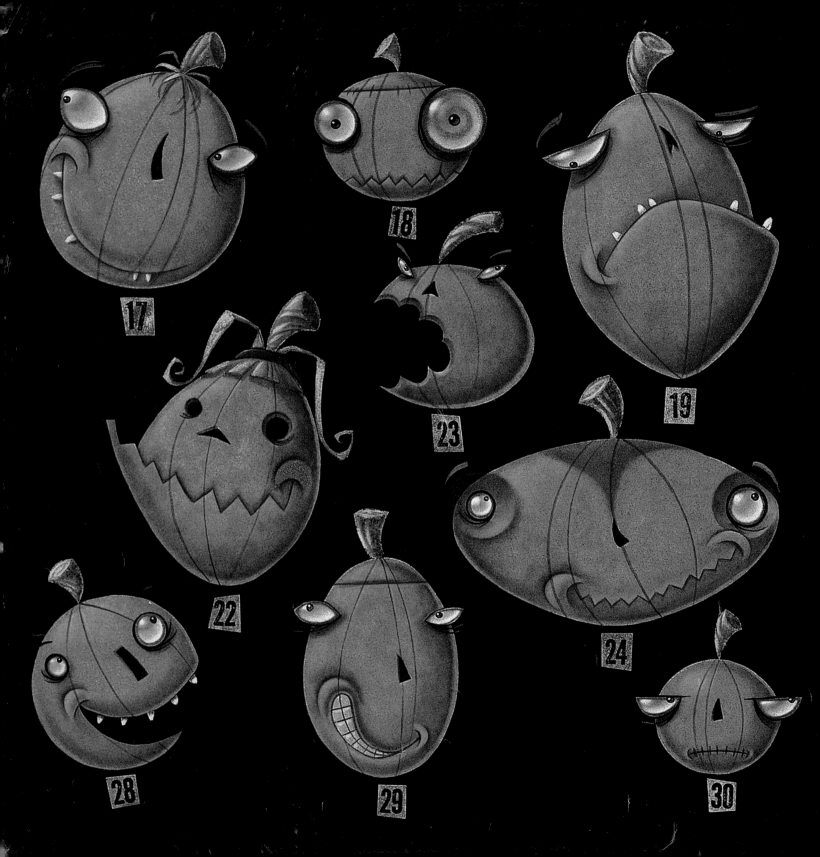

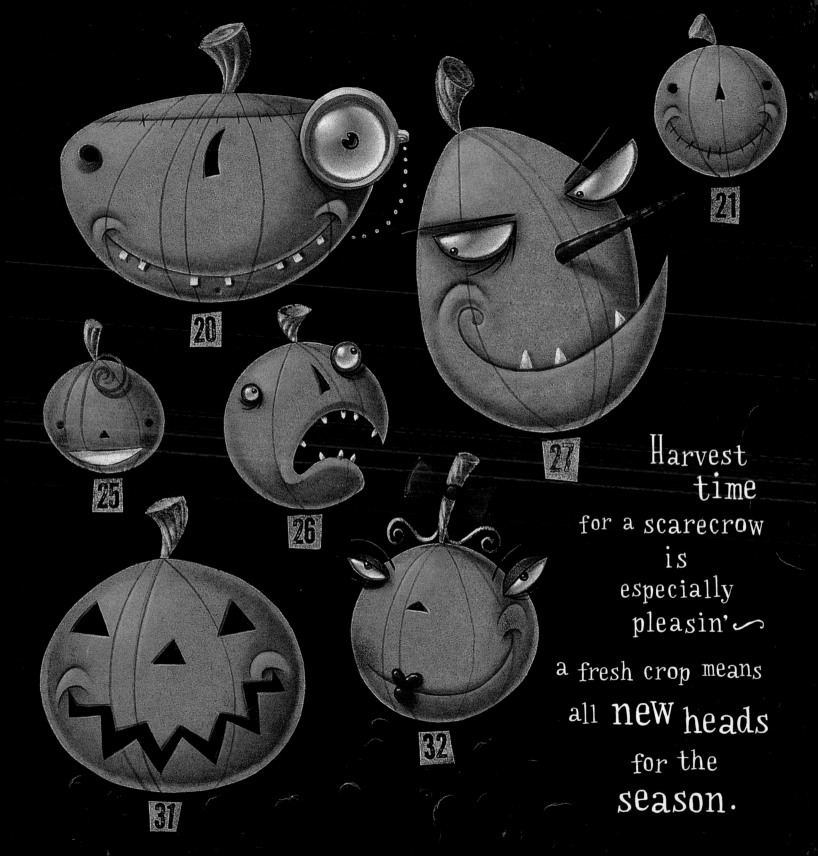

Harvest
time
for a scarecrow
is
especially
pleasin'

a fresh crop means
all new heads
for the
season.

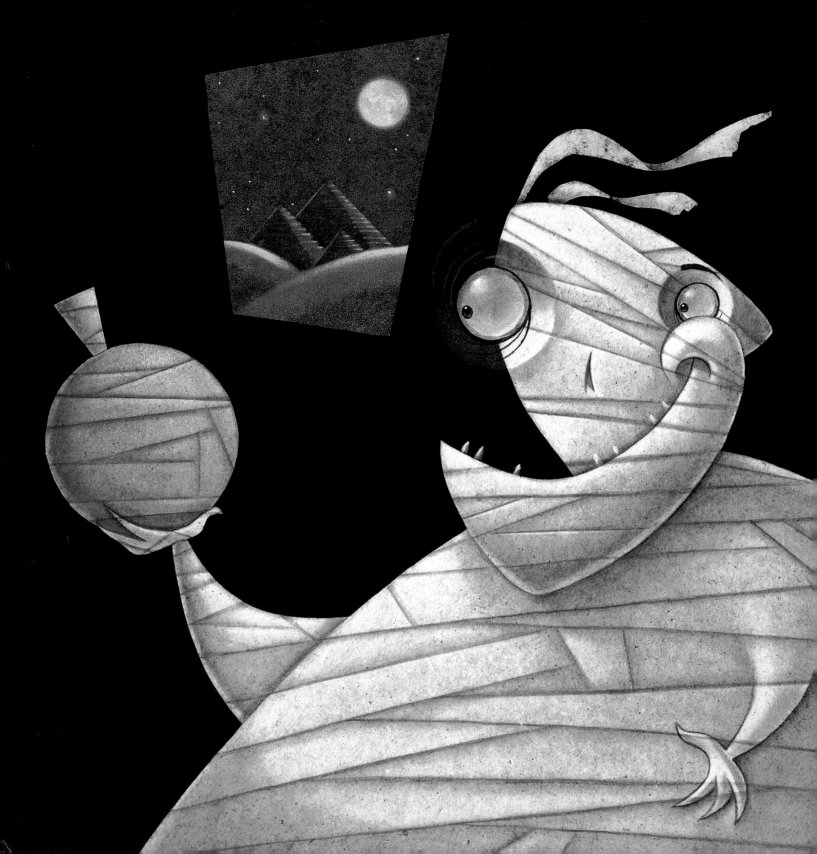

A

little known Pharaoh

now at rest near the Nile

praised the great Cucurbita-

pumpkin goddess of style.

A daring young devil
on all the full moons
juggles pumpkins while singing
selected show tunes.

He'll take a request
if put on the spot,
then he lights up
the pumpkins

and

juggles

them

hot.

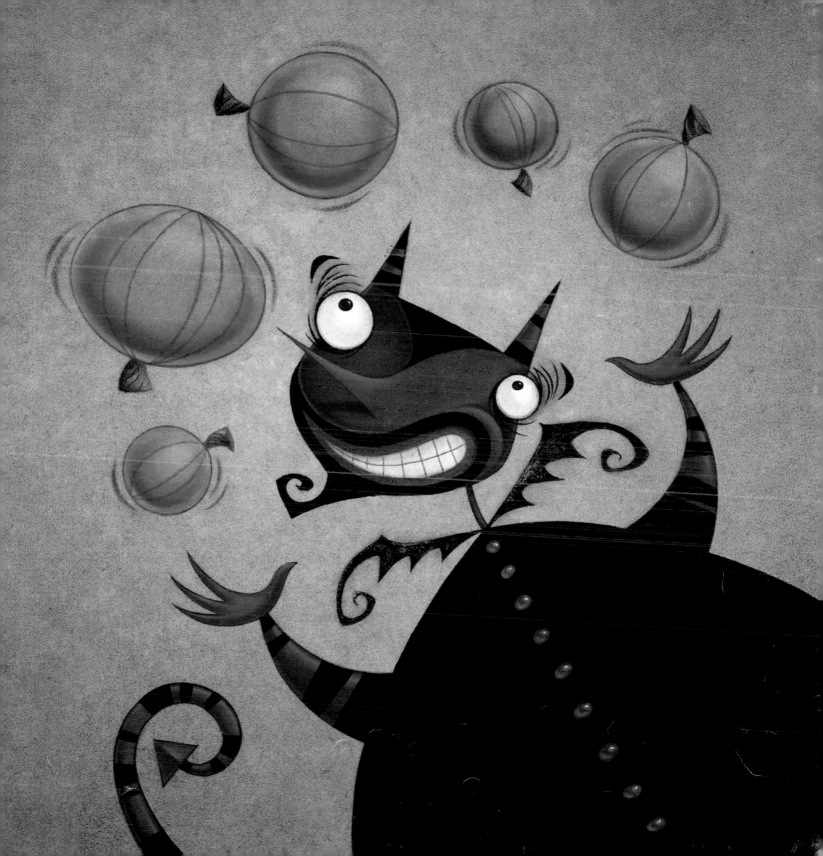

It may seem a bit batty
or even bizarre,

the first time you see
a bat driving a car.

Made up of a pumpkin with corn-plated wheels~

Hear how it rumbles and its passengers squeal!!

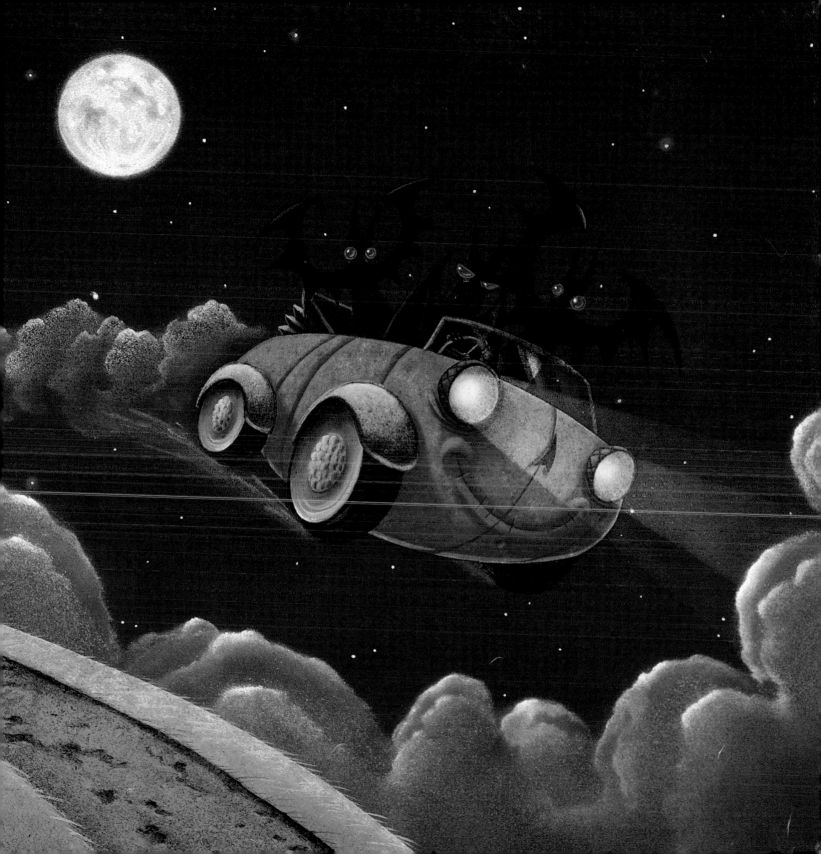

Out-of-sight creatures throughout outer-space

know there's only one planet~ only one place

to find just the thing
that's worth the long trip

to outfit a state-of-the-art sort of ship.

The pumpkin is simply a perfect design,

It's the only such squash that has inside its shell — a seedy slick substance that helps it propel

so aerodynamically orbit inclined.

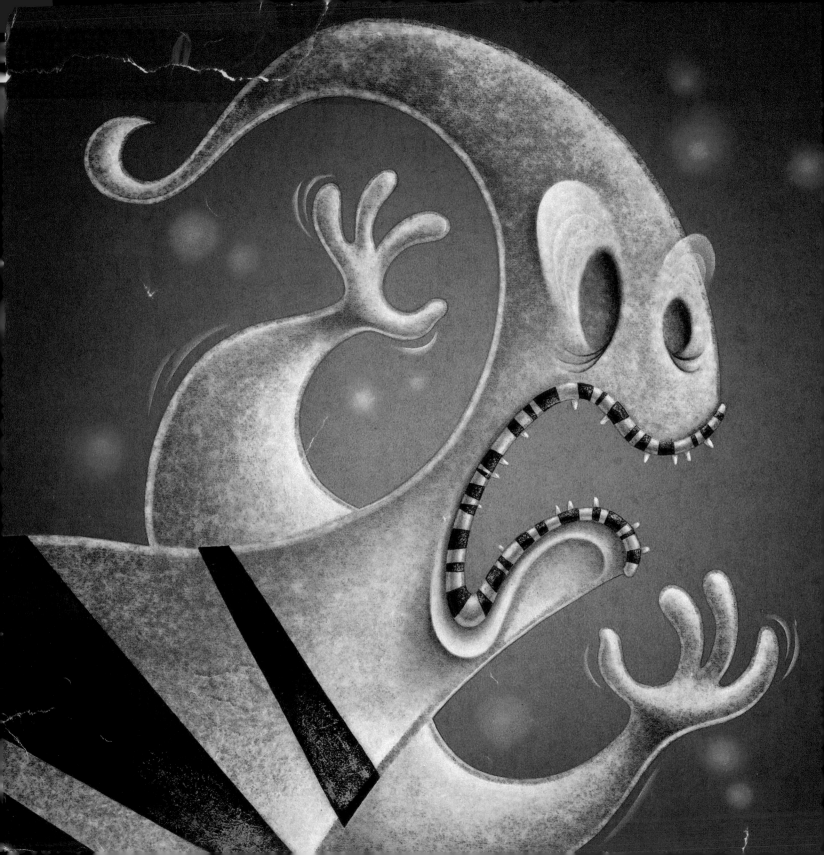

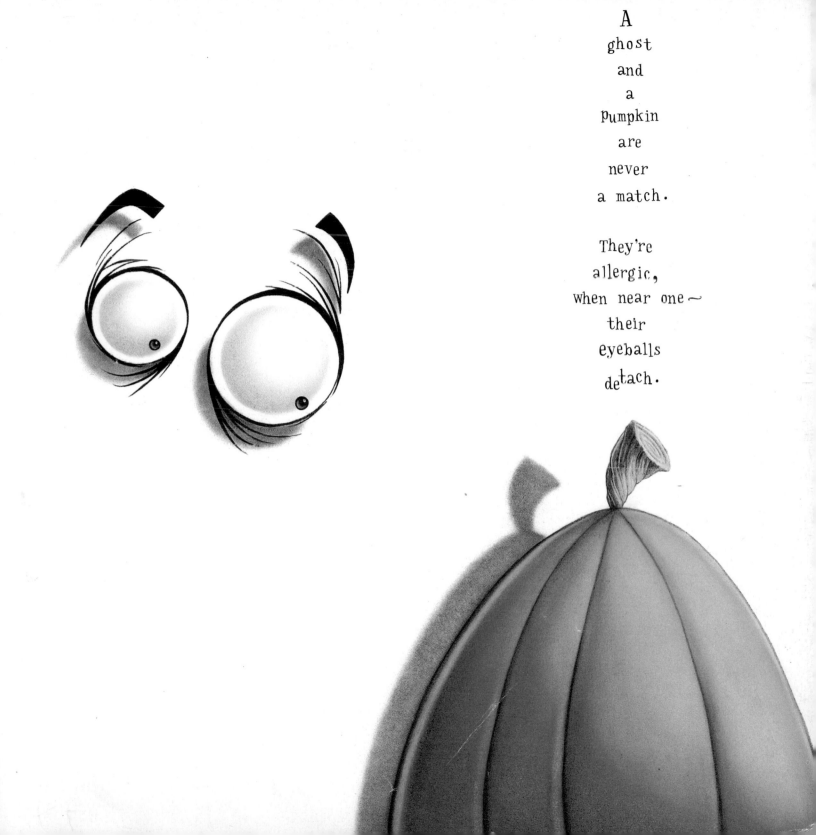

A
ghost
and
a
pumpkin
are
never
a match.

They're
allergic,
when near one ~
their
eyeballs
detach.

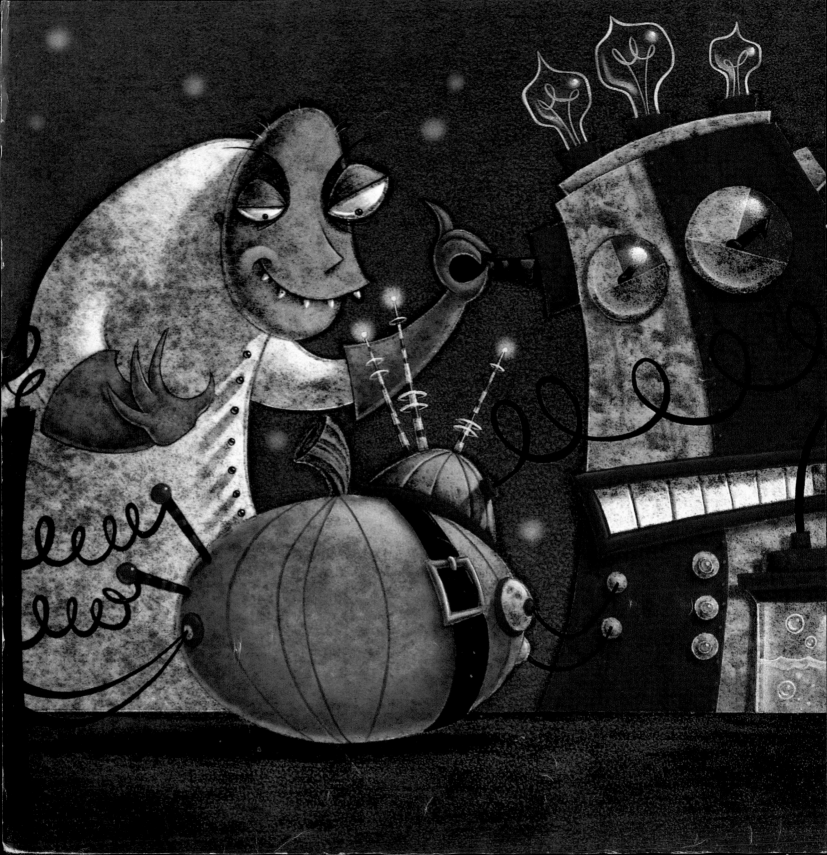

Dr. Von Vrudel says a pumpkin is best~ for conducting a squashastic aptitude test.

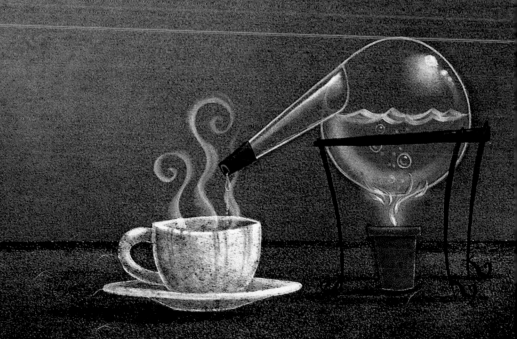

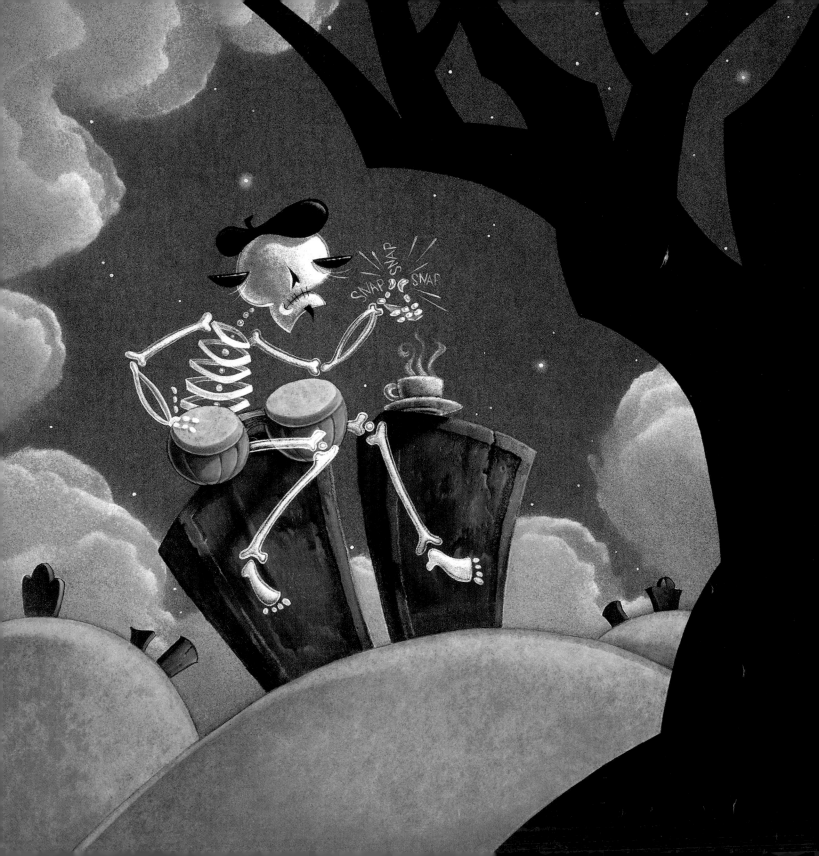

Slim and his BONGOS
sure drum up the beat—
a pumpkin percussional
bone-a-fide treat!

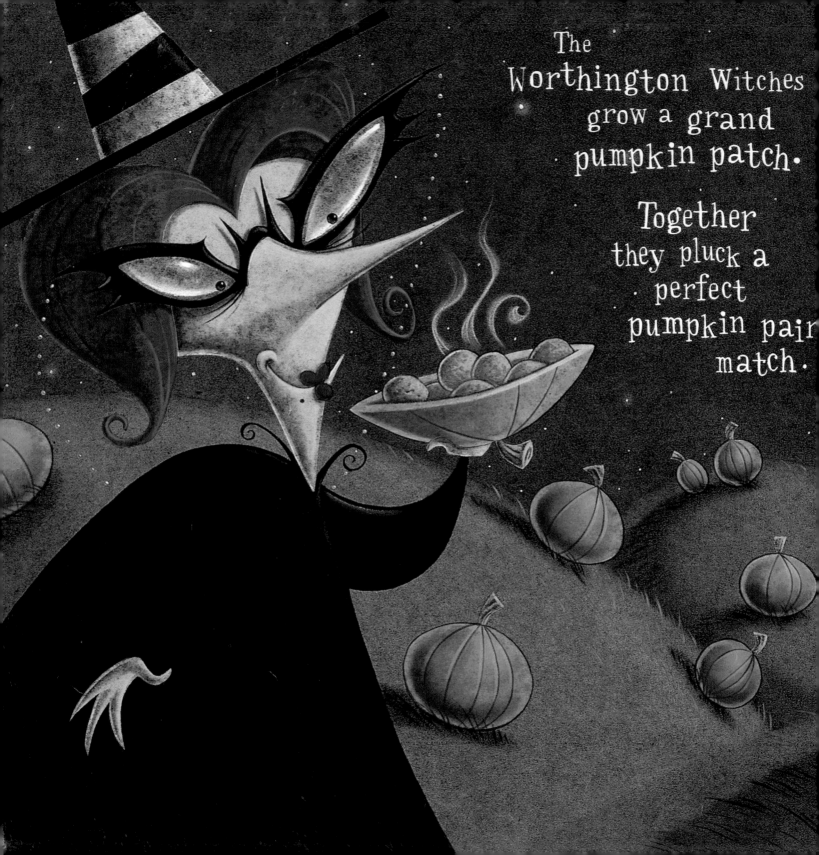

The Worthington Witches grow a grand pumpkin patch.

Together they pluck a perfect pumpkin pair match.

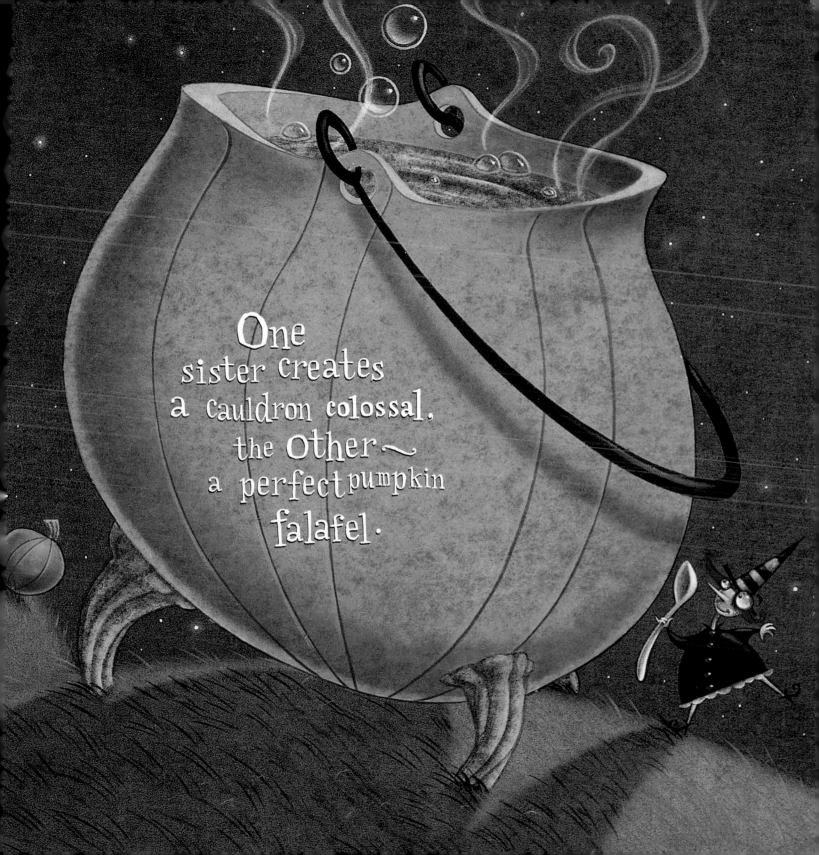

One
sister creates
a cauldron colossal,
the Other~
a perfect pumpkin
falafel.

A pumpkin is possibly so many things

There's no limit to all of the joy that it brings.

No limits at all to the things it can be ⁓

I'll bet you could think up

at least two or three!

Smallfellow Press

A Division of Tallfellow Press, Inc
and Every Picture Tells A Story, Inc.
1180 South Beverly Drive, Los Angeles, CA 90035

Distributed to the trade by
Andrews McMeel Distribution Services
4520 Main Street
Kansas City, Missouri 64111

Creative Producer: Troy Winterrowd
Type and Layout: Scott Allen

ISBN 1-931290-00-8

Printed in Italy
10 9 8 7 6 5 4 3 2 1

You can find the art of Jimmy Pickering
and many other illustrators at:
everypicture.com